For oral administration as directed by your doctor, see enclosed leaflet.
Keep all medicine out of reach of children.
Avoid exposure of skin to direct sunlight or sun lamps.

Damien Hirst ®

Pictures from The Saatchi Gallery.

Booth-
Clibborn
Editions

First Published in 2001 by
Booth-Clibborn Editions
12 Percy Street
London
W1T 1DW
www.booth-clibborn.com

Designed by Jason Beard at Barnbrook Studio

The information in this book is based on material supplied to Booth-Clibborn by The Saatchi Gallery. While every effort has been made to ensure its accuracy, Booth-Clibborn Editions does not under any circumstances accept responsibility for any errors or omissions.

A Cataloguing-in-Publication record for this book is available from the Publisher.

ISBN 1-86154-212-7

Printed and bound in Hong Kong by Toppan

Damien Hirst ®

Pictures from The Saatchi Gallery.

 Booth-
Clibborn
Editions

 28 Tablets

The Physical Impossibility of Death in the Mind of Someone Living/ Amphotericin B/Away From the Flock/A Thousand Years/Beautiful, Kiss My Fucking Ass Painting/Isolated Elements Swimming in the Same Direction for the Purpose

of Understanding/Some Comfort Gained from the Acceptance of the Inherent Lies in Everything/ Holidays/No Feelings/ Argininosuccinic Acid/ Horror at Home/Beautiful, Cheap, Shitty, Too Easy.../This Little Piggy Went to Market, This Little

Piggy Stayed at Home/
Zeolite Mixture/Untitled/
Contemplating a Self-
Portrait (as a Pharmacist)/
The Last Supper/Hymn/
Spot Mini/Love Lost

Use only as directed by a physician

KEEP OUT OF REACH
OF CHILDREN

Store in a dry place

L/M-FM-P-GY

Hirst Products Limited
Welwyn Garden City England

PLATES

DAMIEN HIRST
50 mg

The Physical Impossibility of Death in the Mind of Someone Living (detail)

010

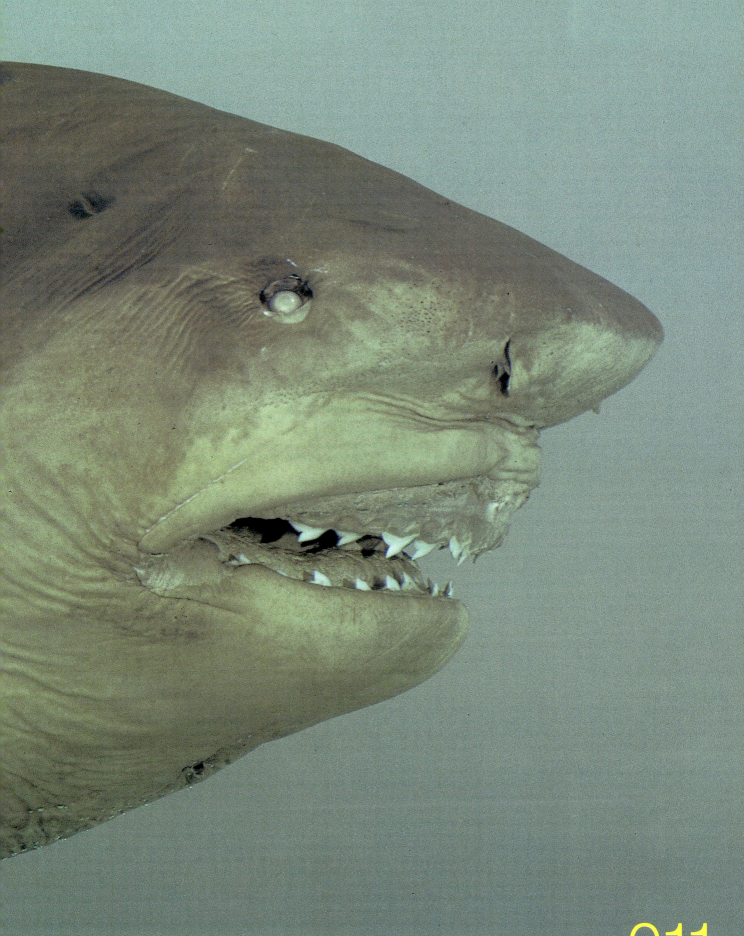

011

The Physical Impossibility of Death in the Mind of Someone Living

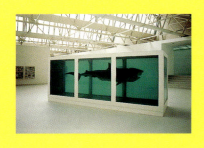 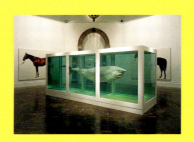 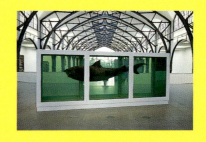

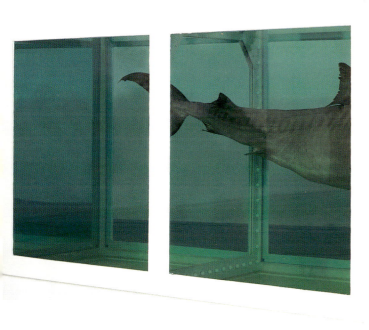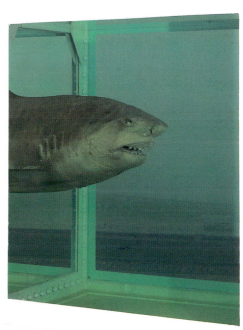

013

Amphotericin B

014

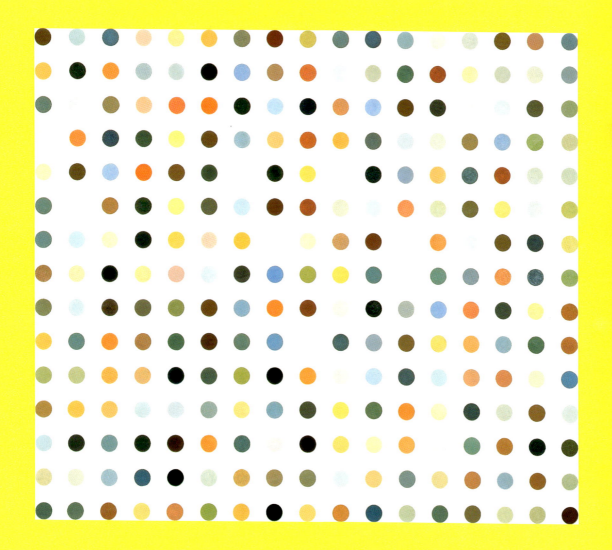

015

Away From the Flock

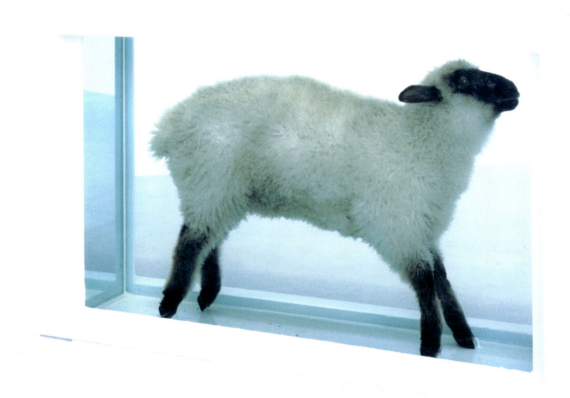

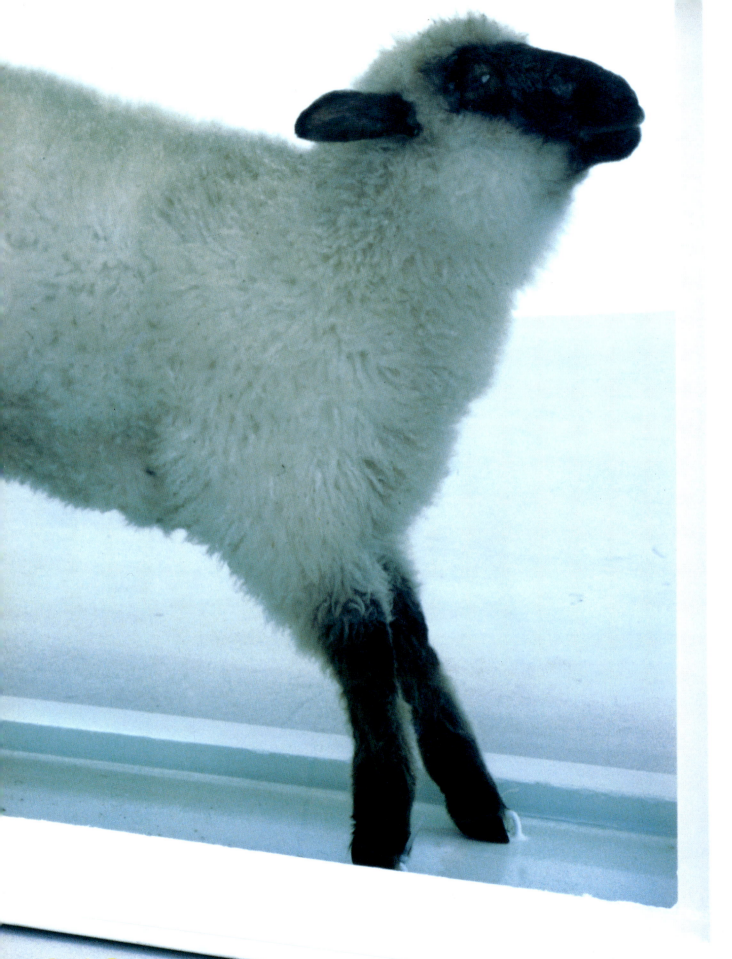

018

Away From the Flock
(detail)

019

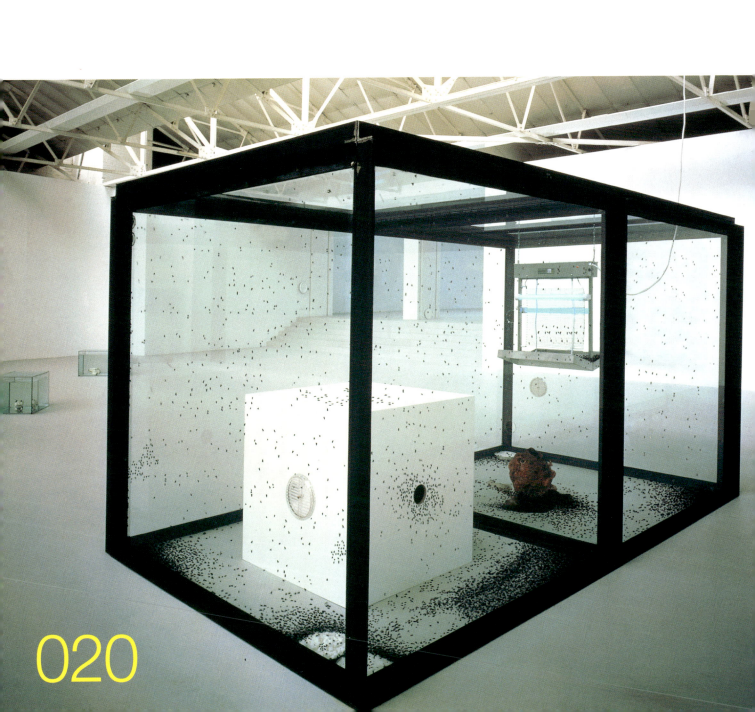

020

A Thousand Years

Beautiful, Kiss My Fucking Ass Painting

022

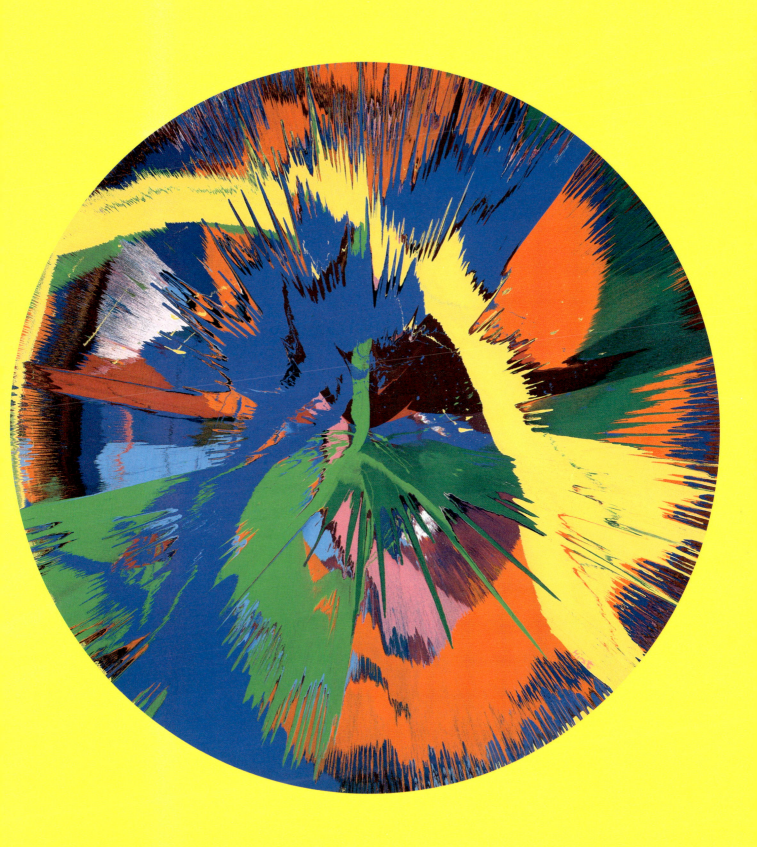

023

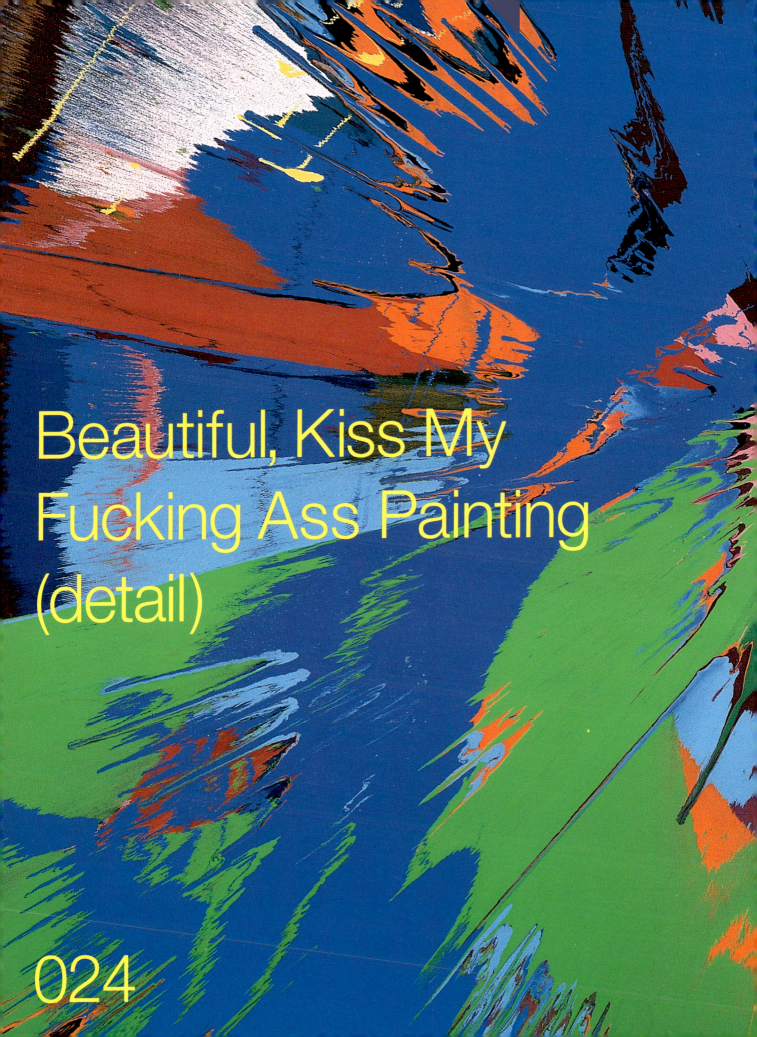

Beautiful, Kiss My Fucking Ass Painting (detail)

024

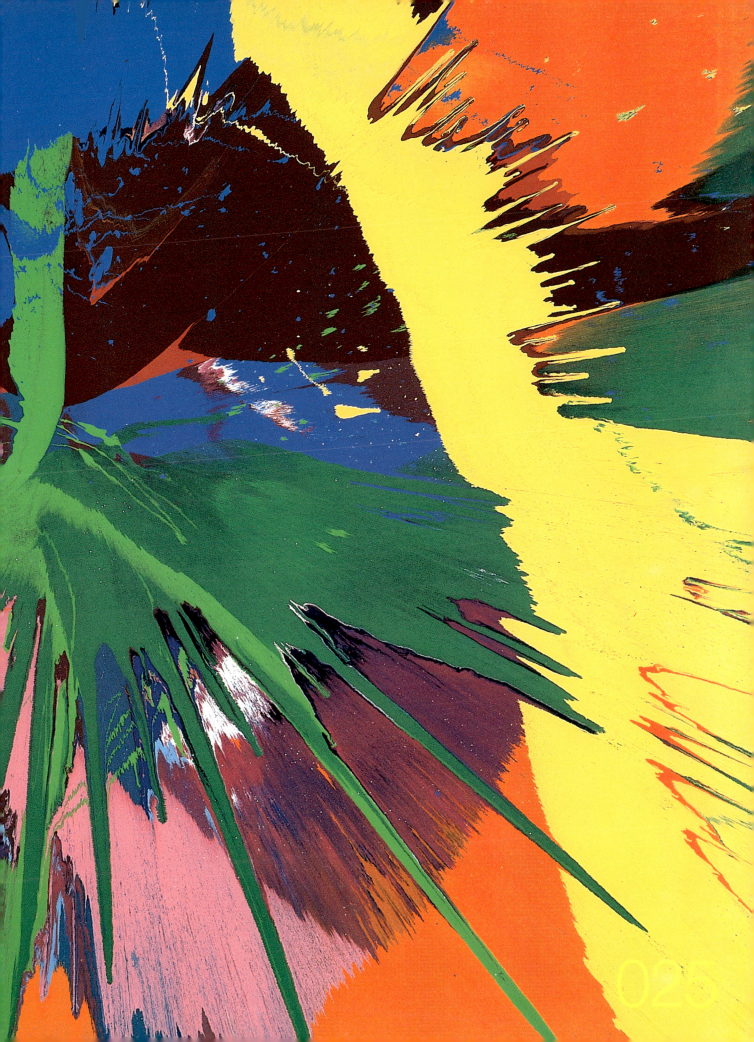

025

Isolated Elements Swimming in the Same Direction for the Purpose of Understanding

026

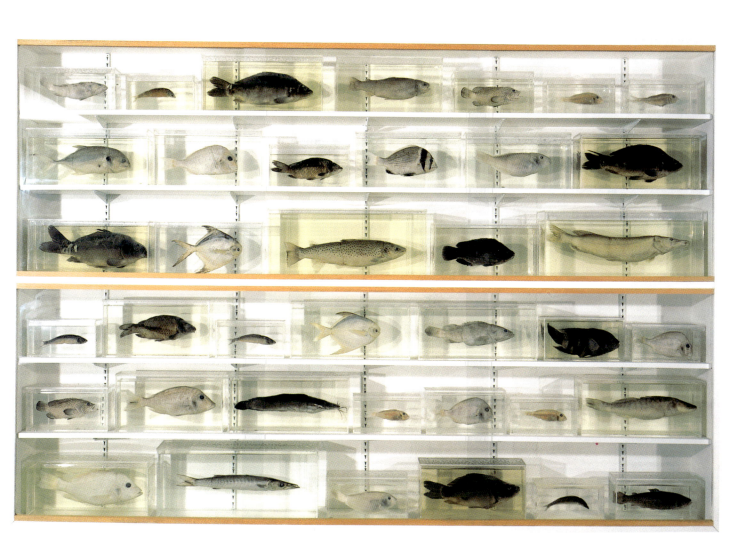

027

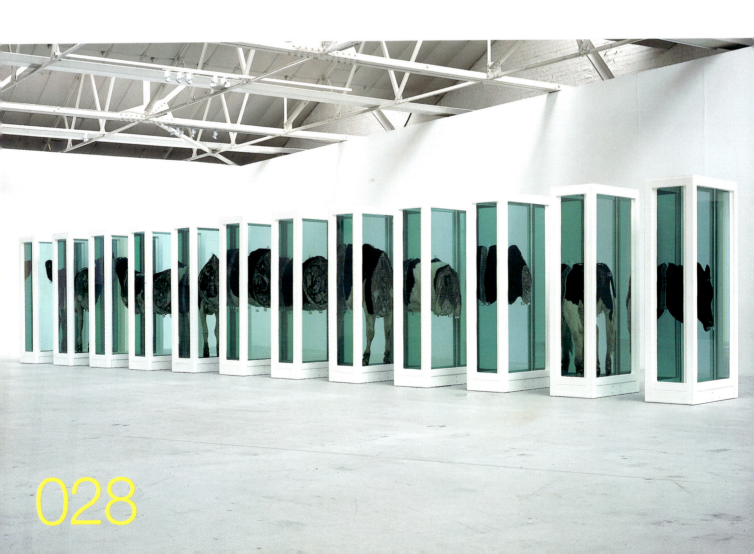

Some Comfort Gained from the Acceptance of the Inherent Lies in Everything

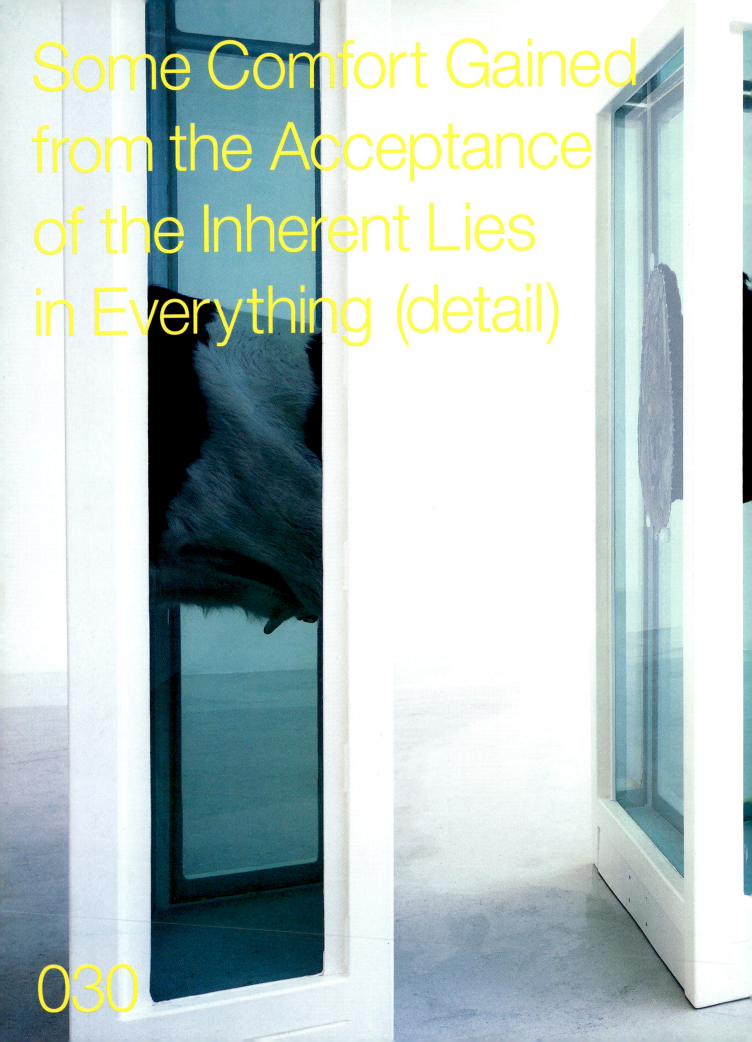

Some Comfort Gained
from the Acceptance
of the Inherent Lies
in Everything (detail)

030

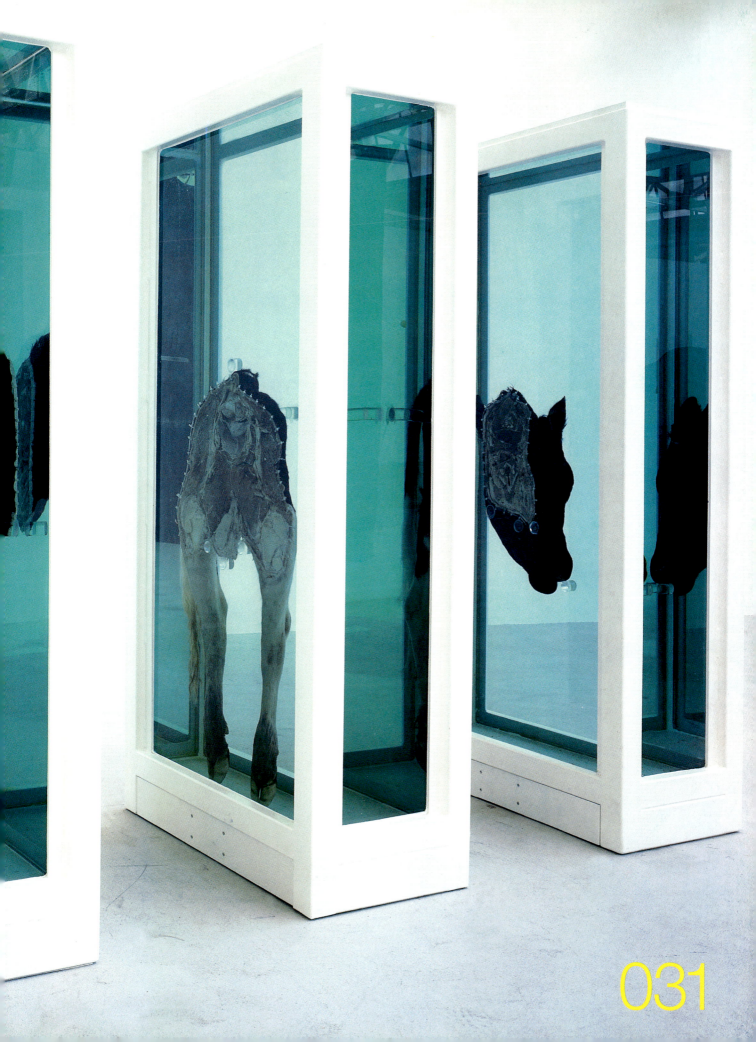

Holidays No Feelings

032

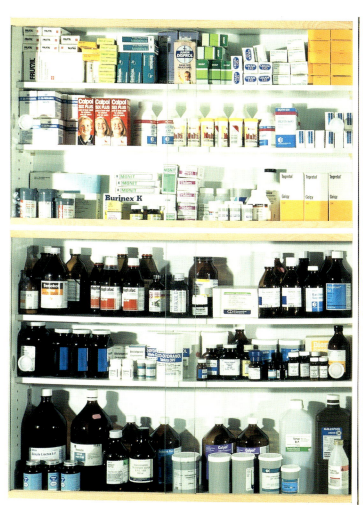
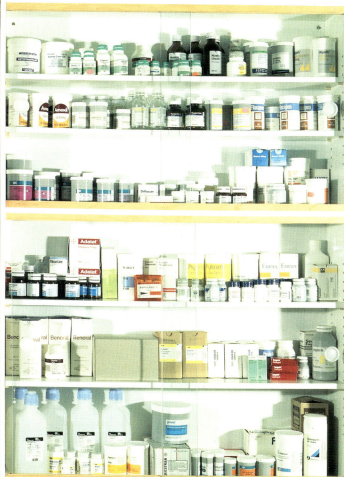

033

Holidays (detail)

034

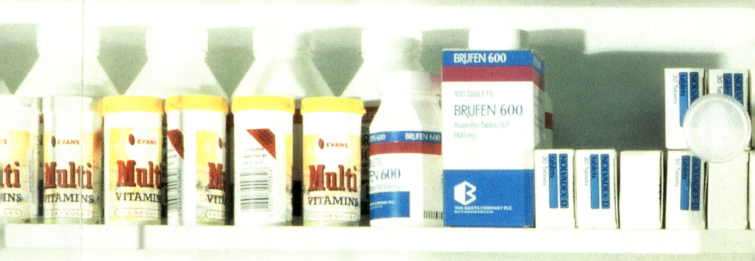
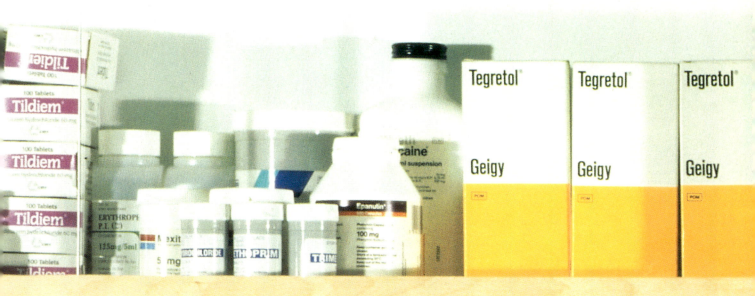
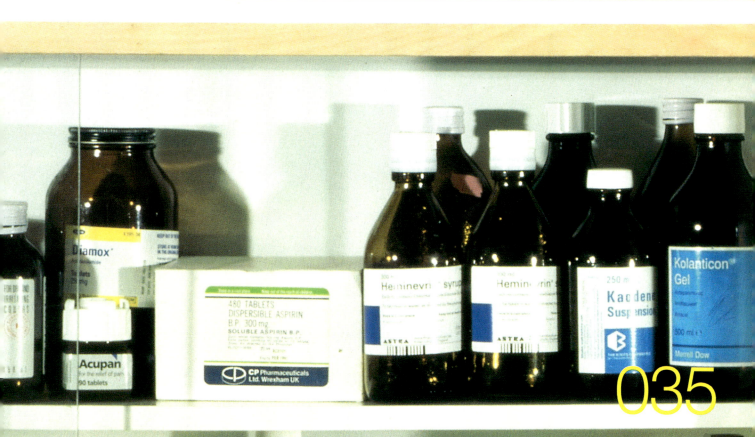

035

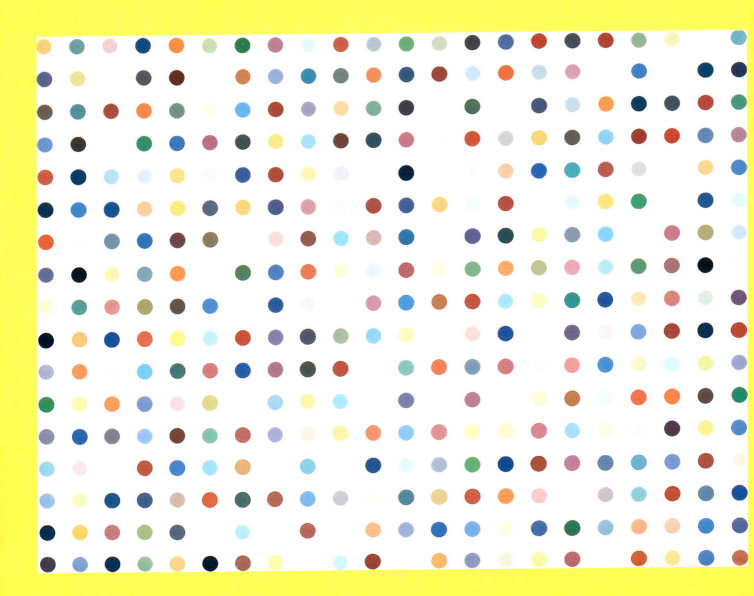

036

Argininosuccinic Acid

°037

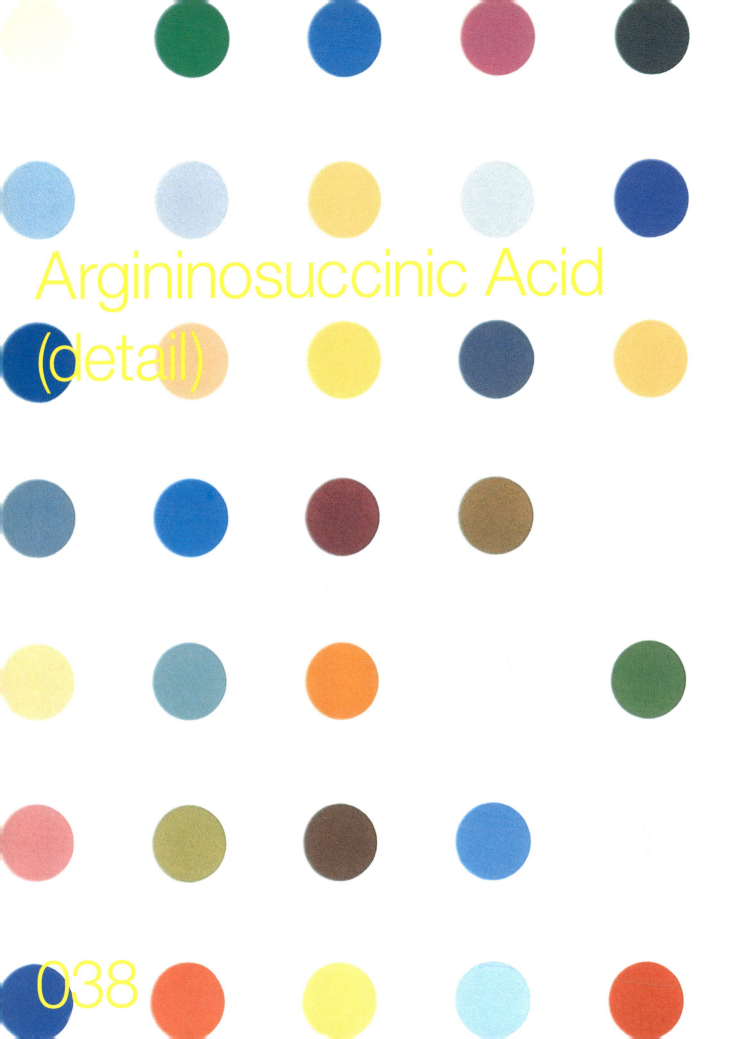

Argininosuccinic Acid
(detail)

038

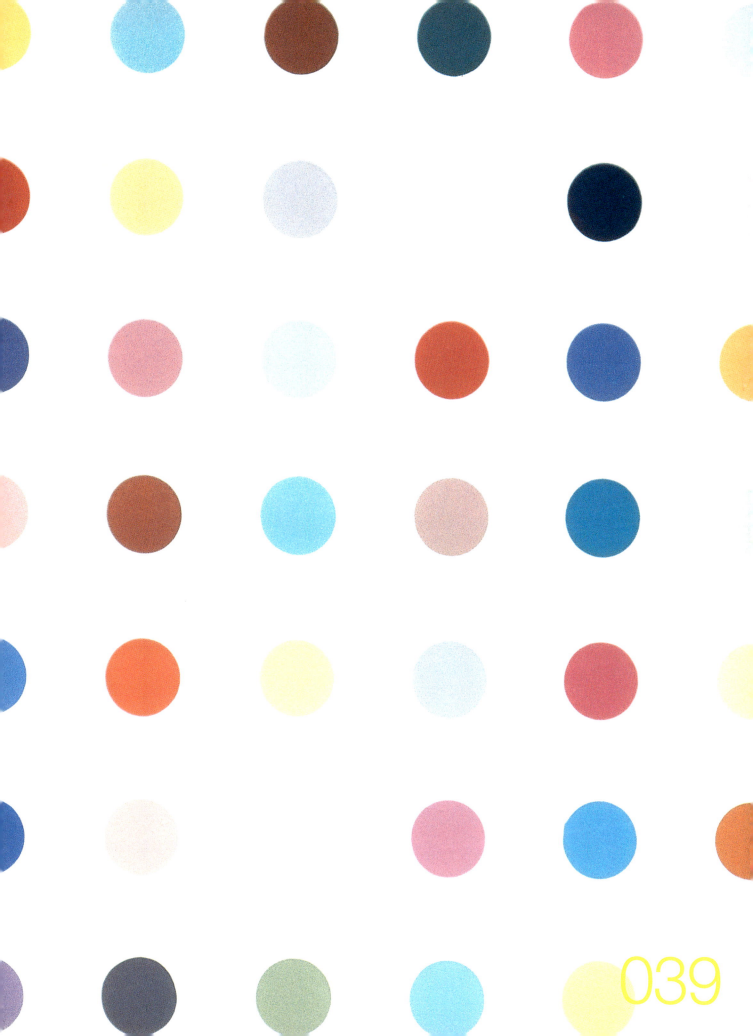

039

Horror at Home (detail)

040

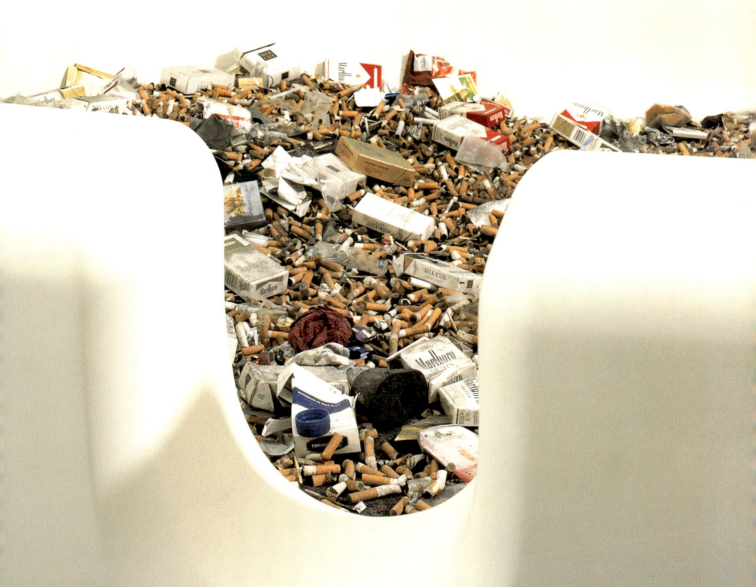

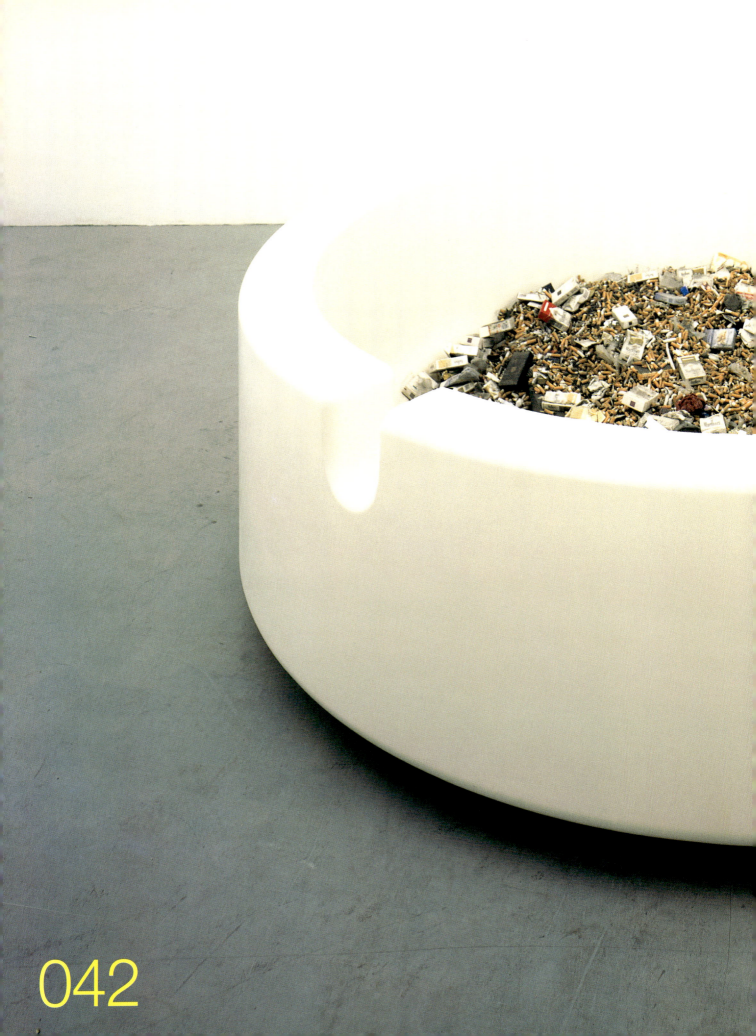

042

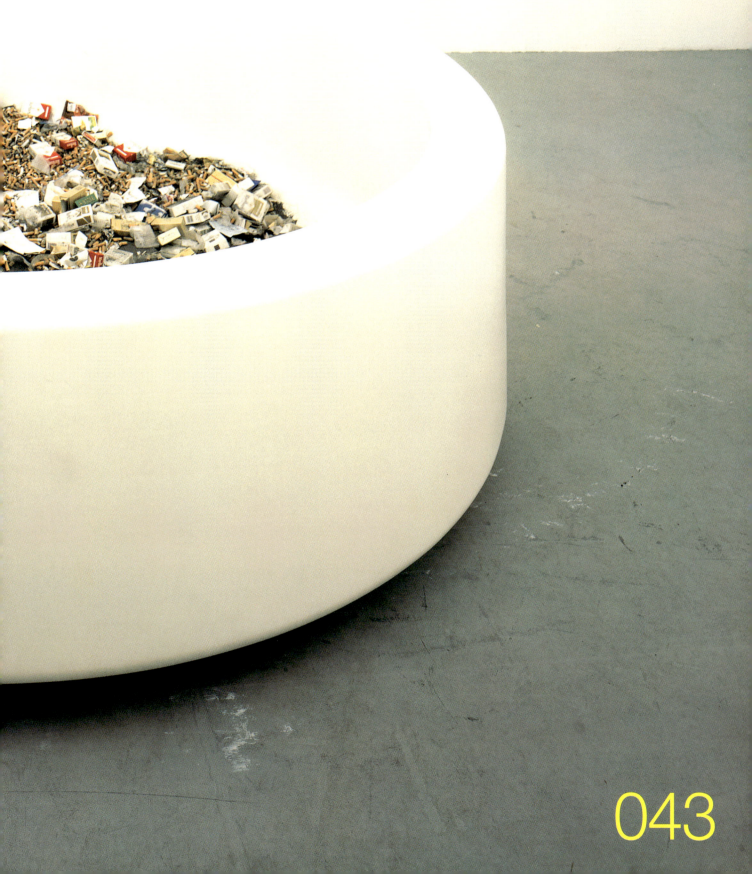

Beautiful, Cheap, Shitty, Too Easy...

044

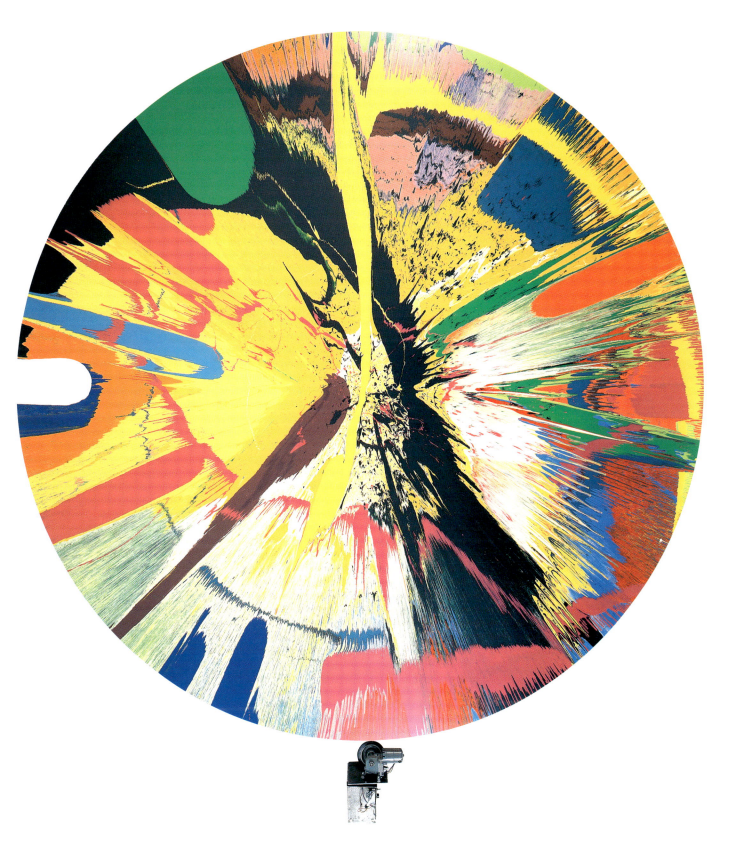

045

Beautiful, Cheap, Shitty, Too Easy…
(detail (spinning))

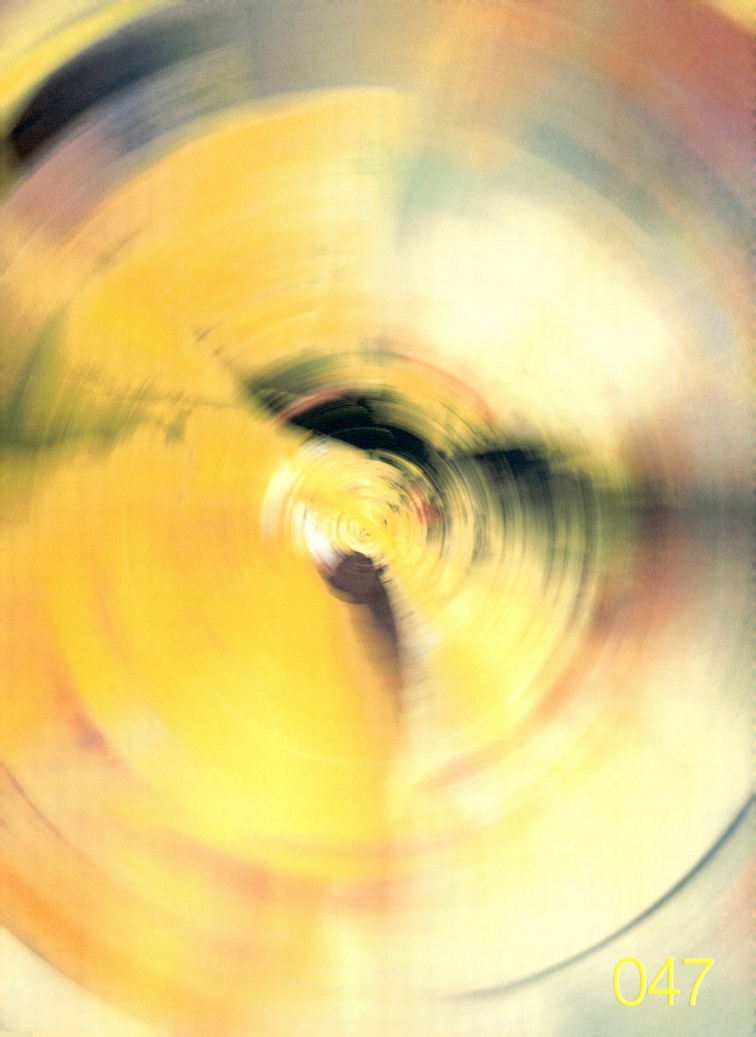

047

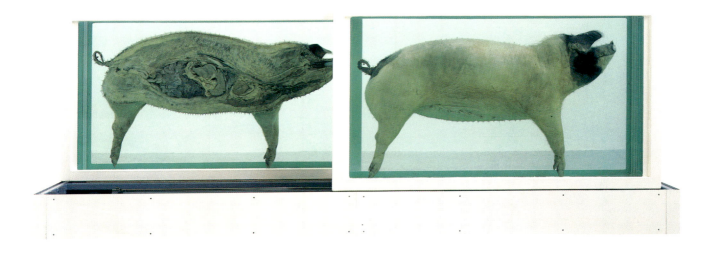

This Little Piggy Went to Market, This Little Piggy Stayed at Home

049

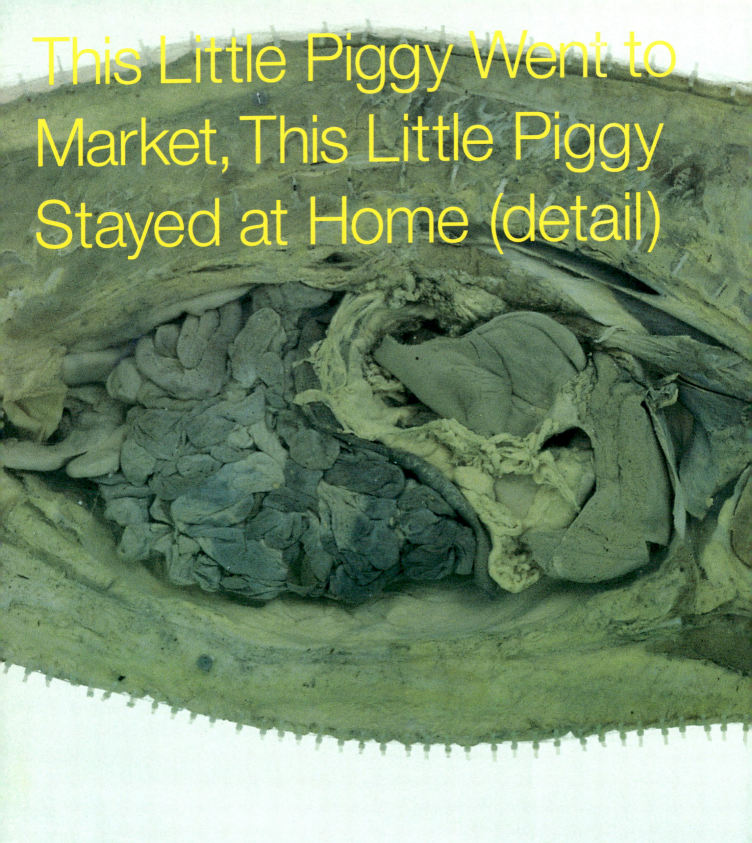

This Little Piggy Went to Market, This Little Piggy Stayed at Home (detail)

050

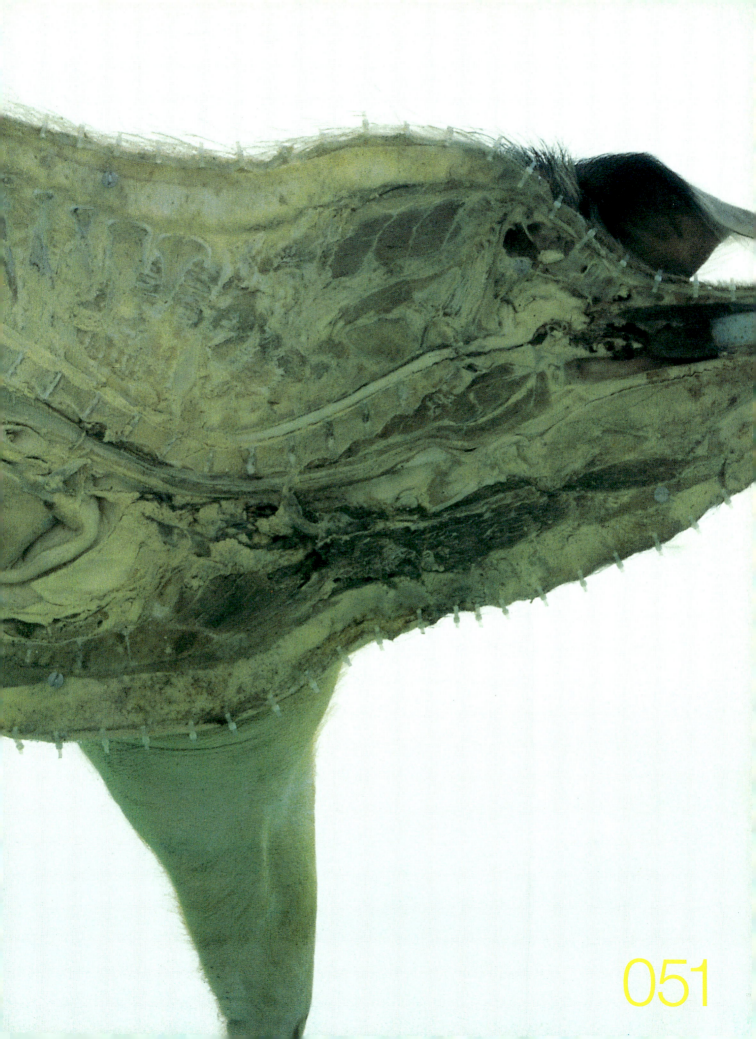

051

Zeolite Mixture

052

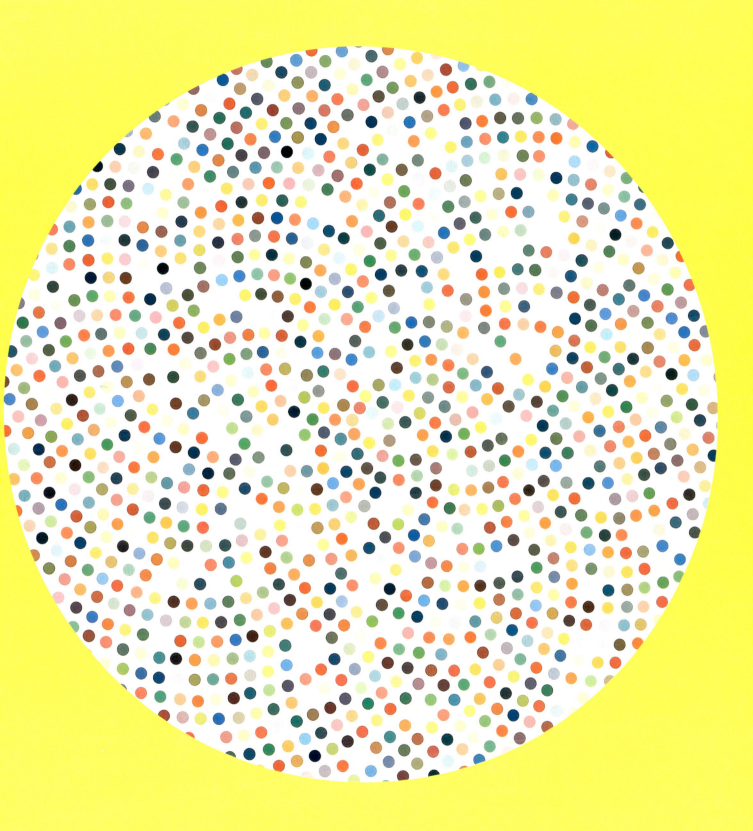

053

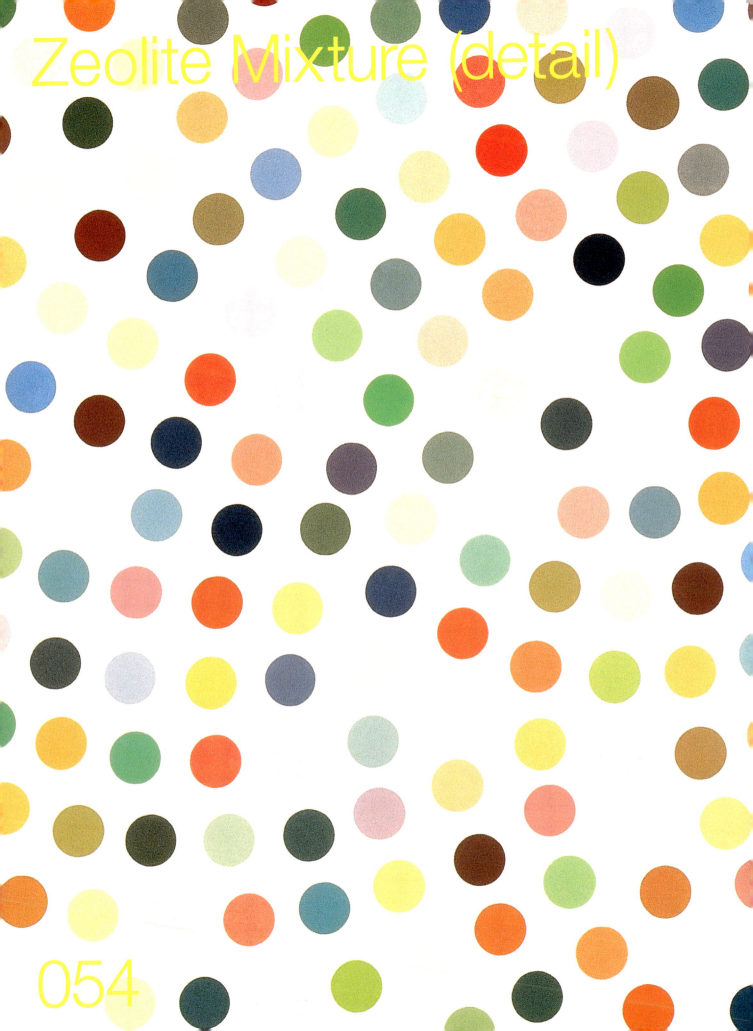

Zeolite Mixture (detail)

054

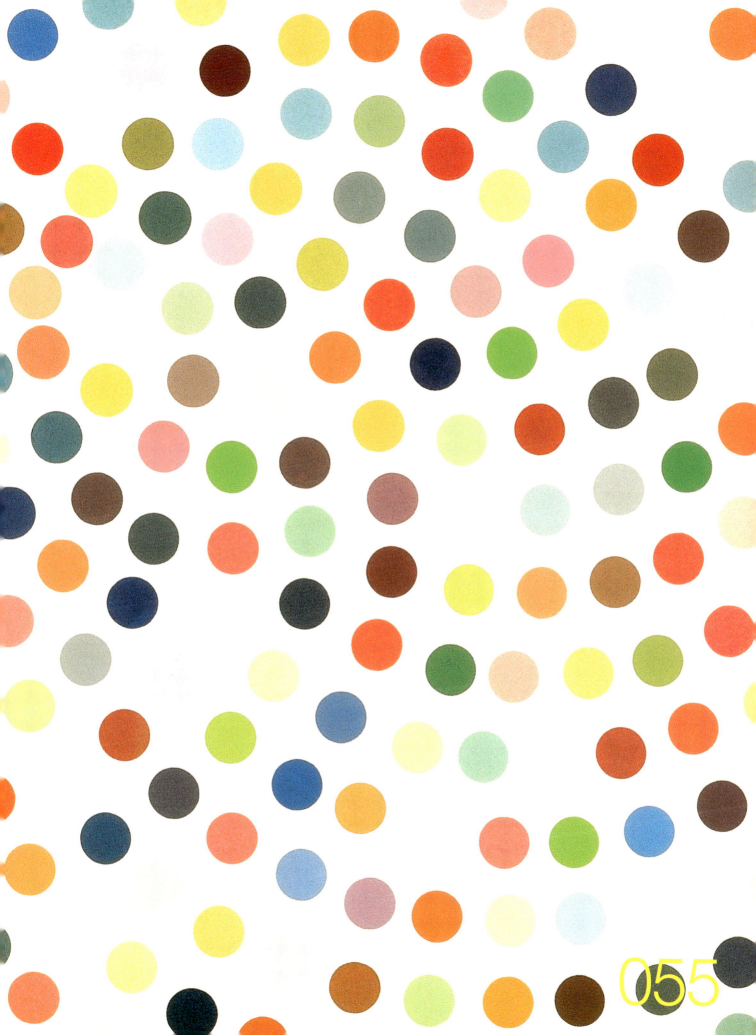

055

Untitled

056

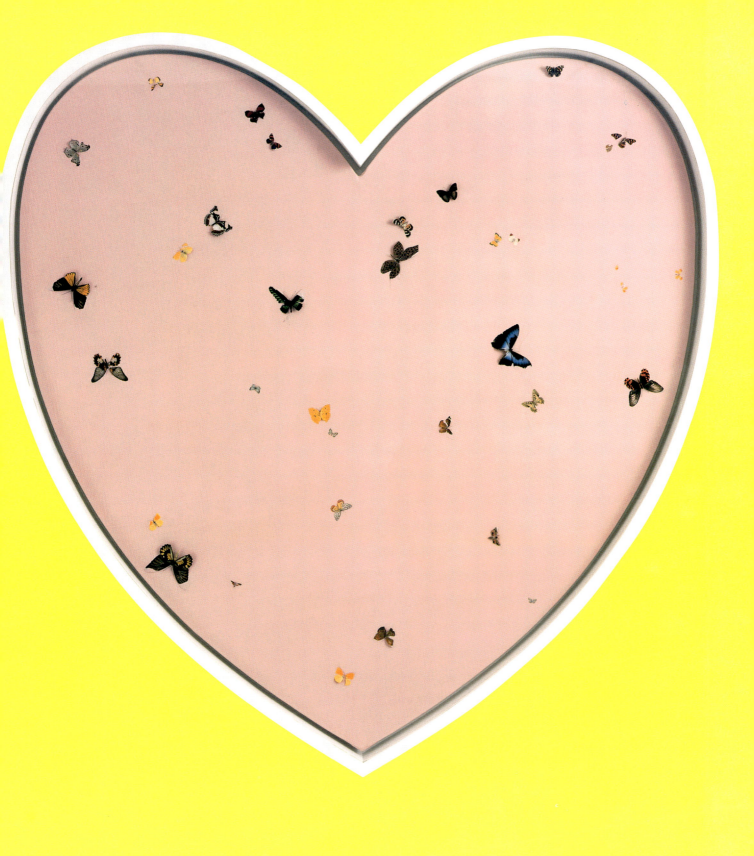

057

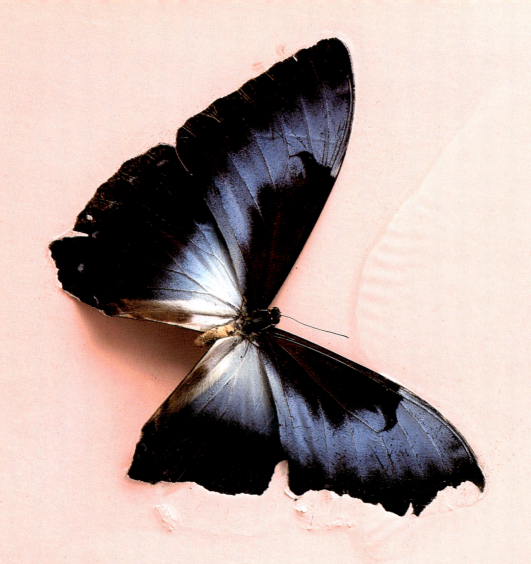

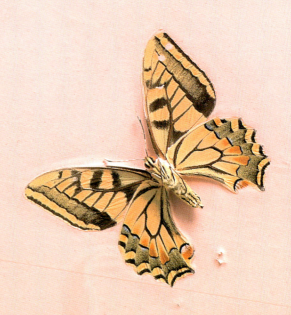

Contemplating a Self-Portrait (as a Pharmacist)

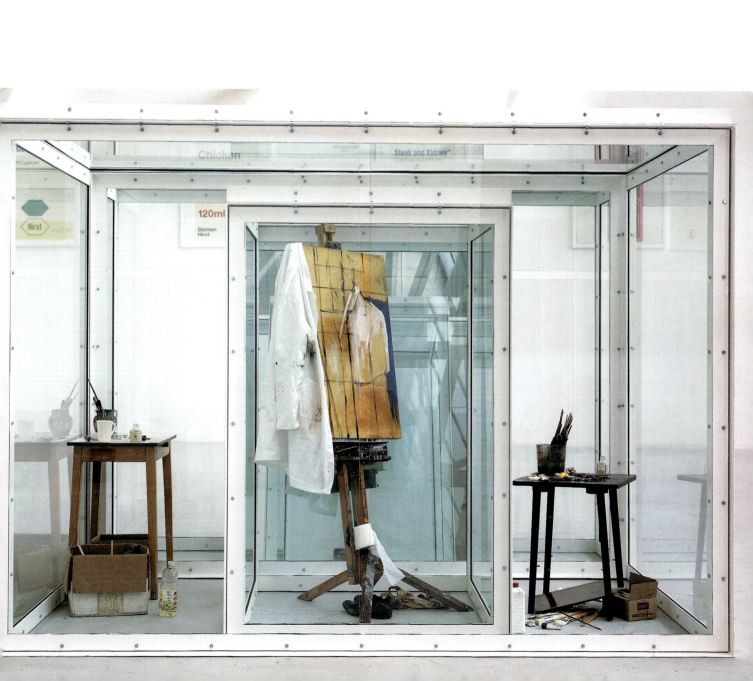

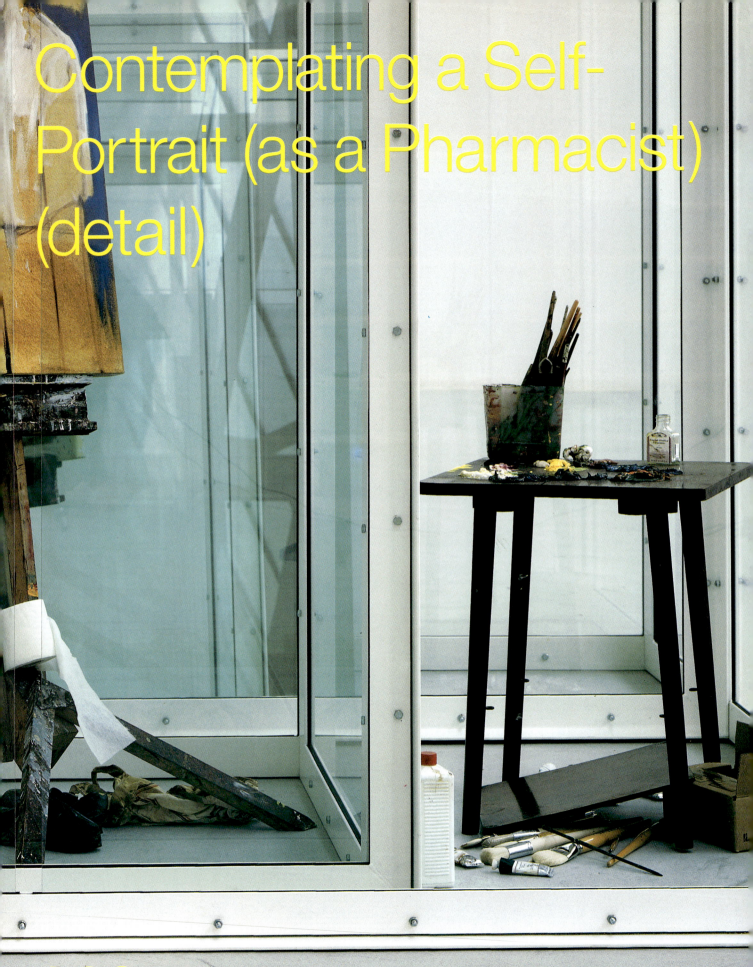

Contemplating a Self-Portrait (as a Pharmacist) (detail)

The Last Supper

064

Chicken®

Concentrated Oral Solution
Morphine Sulphate

20mg/ml

Each 1ml contains Morphine
Sulphate BP 20mg

120ml

Damien
Hirst

065

Omelette

tablets 8mg

Each tablet contains
8mg ondansetron
as ondansetron hydrochloride dihydrate
Also contains lactose and maize starch

10 tablets

HirstDamien

Mushroom™

**30 tablets
Pyrimethamine
Tablets BP**

25mg

PIE

HirstDamien

Salad ™ **tablets**
Lamivudine

Each coated tablet contains
lamivudine 150mg

60 tablets

HirstDamien

Damien 5036-23

Steak and Kidney*
Ethambutol Hydrochloride

Tablets
400mg

100 Tablets **PIE**

30 Tablets

Meatballs

Hirst

150mg

Each film-coated tablet contains
150mg moclobemide

Use only as directed by a physician

KEEP OUT OF REACH
OF CHILDREN

Store in a dry place

GRAVY

PL0031/0275 PA 50/81/2

Hirst Products Limited
Welwyn Garden City England

Cornish 100mg/5ml Pasty

Rifampicin B.P.

To be taken by mouth

Peas

CHIPS

100ml Syrup

069

Hymn

070

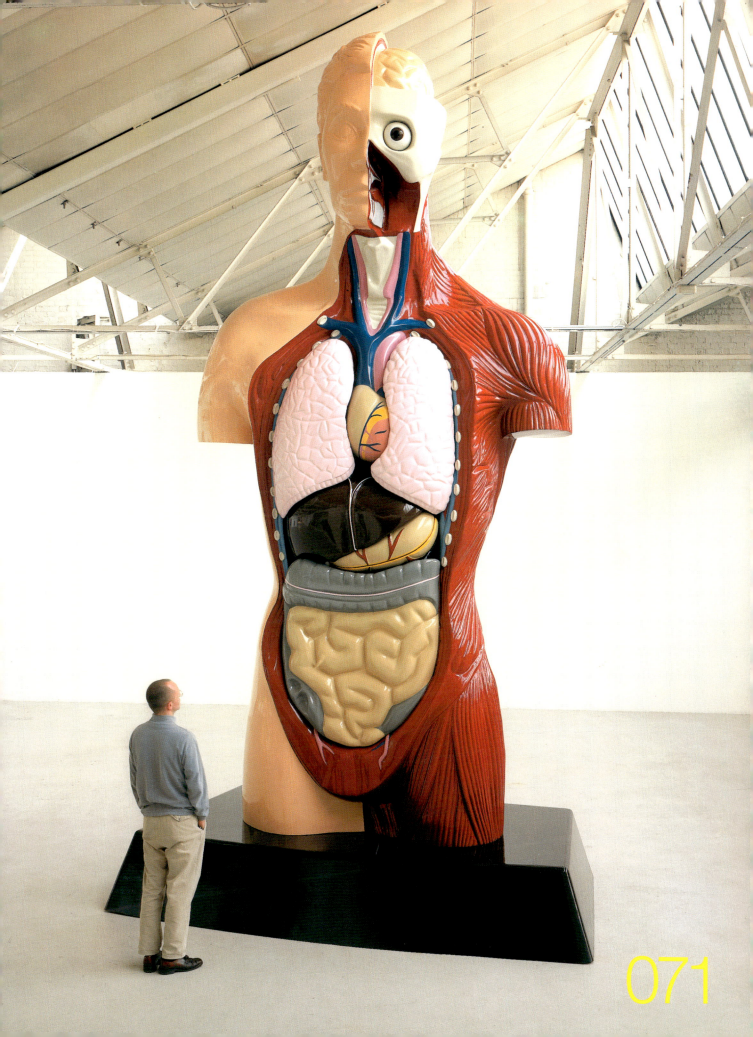

071

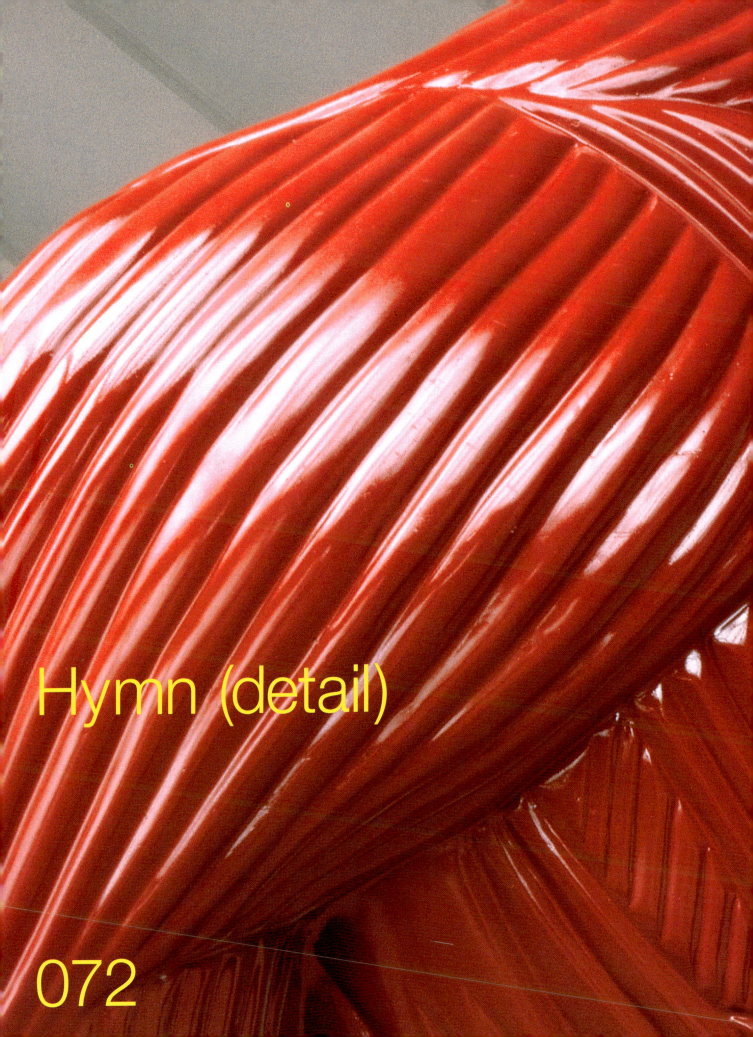

Hymn (detail)

072

073

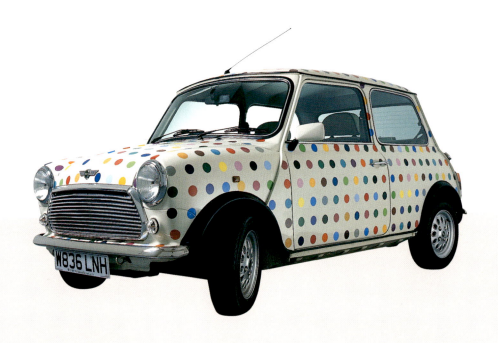

074

Love Lost

076

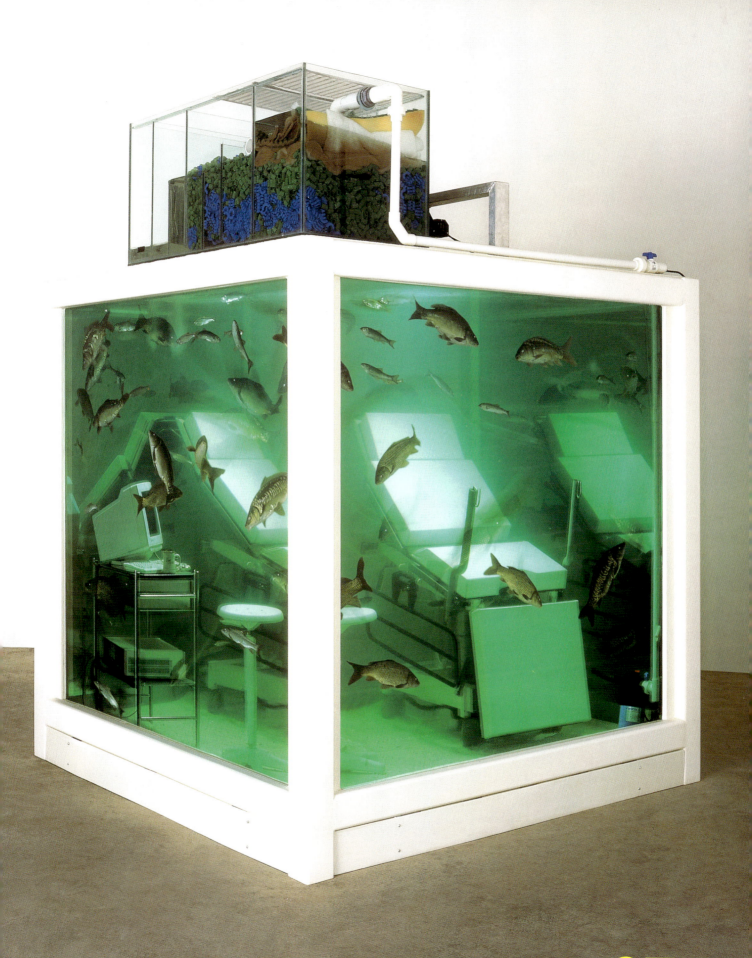

077

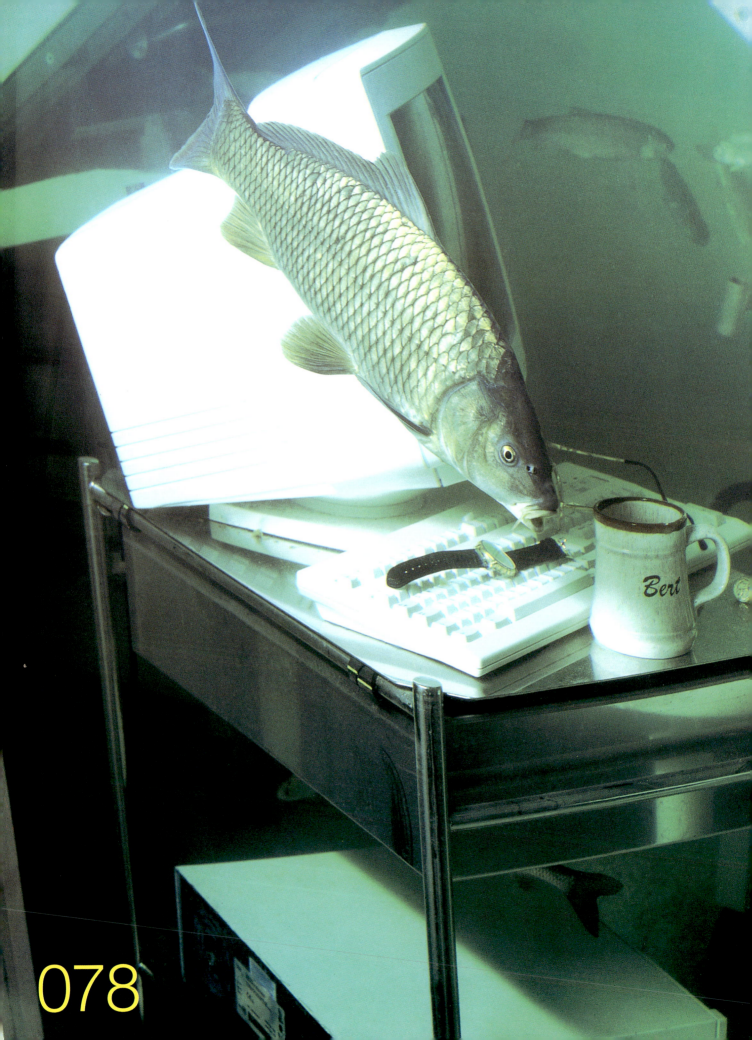

078

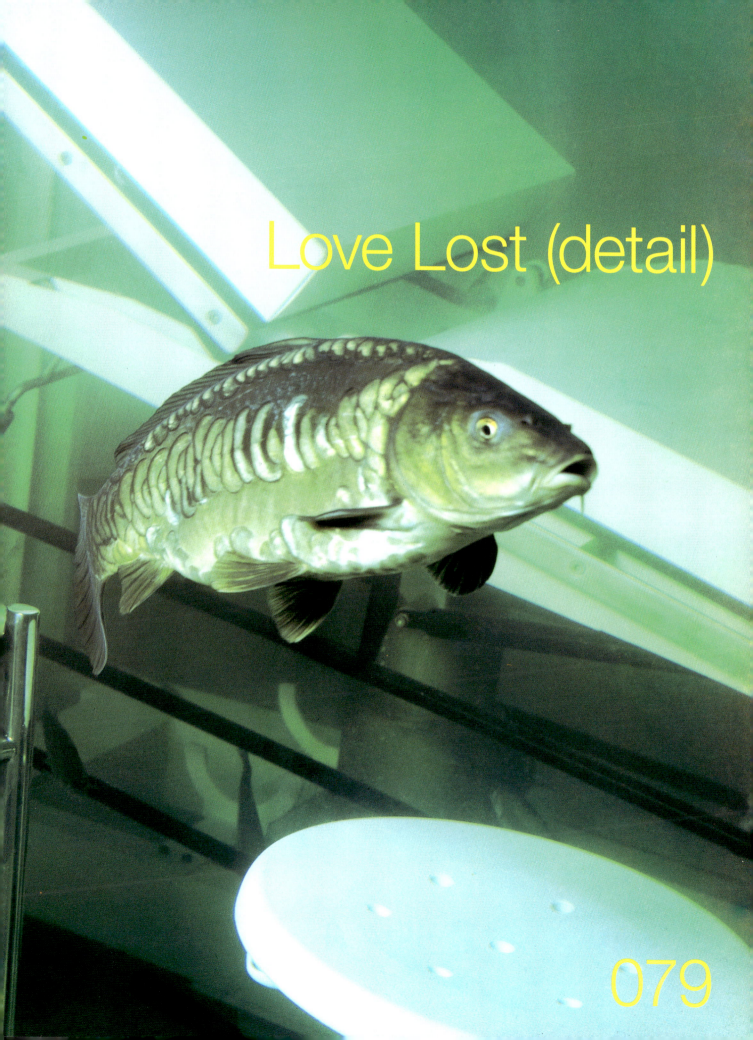

Love Lost (detail)

079

Damien Hirst ®

REF:
1103–2000
06–12–00
BAMB

For oral administration as directed by your doctor, see enclosed leaflet. _____
Keep all medicine out of reach of children.
Protect tablets from light. _____

Illustrated
Works

⧖ Use before. UT – AV. Verwendbir bis. Untare entro.
⧖ Usar Antes Använd Före, Te gebruiken voor: 2003–02

POM

Damien Hirst:

a power
to amaze

Richard
Shone

STERILE

Sterility guaranteed if package unopened or damaged.
Vérifier l'intégrité du protecteur individuel de stérilité avant usage.
Sterilität gewährleistat bei ungeöffneter und unbesschädigter Einzelverpackung.
Sterilitá garantita a confezione integra.
Sterilitet garanterad om forpackningen är oöppnad och oskadad.
Esterilidad asegurada excepto cuando el envase este roto o abierto.

Every so often in British art a figure comes along and enthrals a generation. In the early 1900s, it was Augustus John; in the 1930s, Henry Moore; in the 1950s, Francis Bacon

Hymn
detail
1990

and in the following decade, David Hockney. This swift rise to fame comes about through a manner of working that touches a contemporary nerve and a style of life that reflects the changing sensibilities of a given period. If the work shocks or disturbs by its challenge to prevailing practice or taste, the spotlight is even more glaring. In the early 1990s, Damien Hirst was the chosen one, a media natural who combined toughness with teasing humour, high professionalism with a truth to himself that brooked no compromise. He produced a sequence of extraordinary works, organised memorable exhibitions and became engulfed by the attentions of the media, both friendly and antagonistic, in a way that was unprecedented in the social history of British art. The culminating moment came with his winning the Turner Prize in 1995, an event celebrated by his peers and greeted by a leader in the **Daily Telegraph** as a 'disgusting and odious scandal'. By the time of his inclusion in **Sensation** at the Royal Academy in 1997 – an opportunity for many people who had heard of Hirst but never encountered his work, to see it, as it were, in the flesh – his pre-eminence was made dramatically clear in a group of outstanding works. But Hirst had already drawn

away from the feeding-frenzy of the press, took time off from the hitherto unceasing round of international exhibitions and let the celebrity spotlight shift perceptibly onto others. He became a more solitary figure, only pushed briefly back into the fray when his monumental **Hymn** (pp. 071–073), shown at The Saatchi Gallery last summer, was found to have its origins in a commercially produced educational toy. This incident once more highlighted a recurrent note in the criticism not only of Hirst's work but that of others of his generation – its appropriating closeness to daily life, as though this disqualified it from serious ambition or attention. Detractors feel they are riding the moral uplands when they tell us that Rachel Whiteread's **House** was only a cast, Michael Landy's **Market** only crates and stalls, Tracey Emin's bed just a bed and Hirst's lamb just a lamb. Conversely, for example, the most 'realistic' (i.e. closest to 'real-life') work in **Sensation**, Ron Mueck's **Dead Dad**, was a sure-fire favourite, partly because it was so patently handcrafted. This discrimination between found and artist-made object, the former suggesting lazy cynicism, the latter a skilful engagement sure to reap spiritual dividends, is an old and tedious opposition. It has

bedevilled British reaction to certain strands of modernism from the beginning of the last century. The success of all Hirst's best works, whatever the origin of their components, lies in the brooding, startling, provocative transformation he has effected of his chosen materials.

Hirst is essentially a romantic artist, amazed by the sweep of life, from its grandest themes to its grittiest detail. He is notorious, even in his generation, for his preoccupation with mortality and the easy loss of life. Although the shark fills us with dread, it is dead; the pills and potions of his medicine cabinets become poison; the brightly designed ashtray, a graveyard. This preoccupation with the continuing presence of death-in-life has inevitably attracted the dismissive criticism that he is a sensationalist, a latter-day exponent of Hammer House aesthetics. In fact he is one of the least cynical, least defeatist personalities. His work is essentially life-affirming, even at its most chilling moments.

Commentators frequently isolate Hirst from his generation. In part, this is attributable to his immense fame, but it also suggests that his visual world is a hermetic realm peculiar to him alone. No one would deny, of course, that his

work is unmistakable, full of recognisable signature tunes and idiosyncratic personal elements. But it should be stressed that Hirst has always been hyper-receptive to the work of his contemporaries and forebears – in film, music, television and books as much as in art – and that he emerged alongside a group of artists known for their collaborative spirit and exchange of ideas. British art preens itself on its isolated figures – Blake, Spencer, Bacon – enjoying such supposedly home-made dishes with a John Bullish xenophobia. But Hirst cannot be pigeon-holed in this lazy way. As his interviews and conversation demonstrate, he is unusually alert to what goes on around him and his work shares numerous characteristics with his contemporaries – a fascination with the loss of life and the hairline divide between living and dying; with states of flux and transformation; with desire and frustration; inner order and outer chaos (and vice versa). Going further, I would say that in spite of Hirst's use of unusual materials in unlikely juxtaposition, the perceptions and ideas they embody are in fact **un**extraordinary and have long been the stuff of art.

Two obvious strengths of Hirst's work are a frontal simplicity of

presentation and an ability to invest objects with a direct metaphorical charge. They are, of course, inseparable but when one or the other is out of balance, less convincing or peripheral elements come to the fore. With his propensity for grisly and unsettling images, which could easily spill out into the world of special effects, Hirst walks a tightrope between challenging subject and cooling presentation. Such rebarbative content often deflects attention from work that is restrained, even formally conservative compared with others of his generation. Ideas for works may teem in his mind, but finding palpable solutions needs detachment as well as bravado. In this sense, his work abounds in the tension of opposites. He is distinctly urban in sensibility but known for images taken from the natural world; often bleakly fatalistic in effect, the work has its mordant humour, a blackish mortuary chuckle that is embedded in its making; invariably austere in his use of manufactured elements, he can use colour that is brash or sweetly cloying. In interview he is challengingly paradoxical, verbalising antitheses in order to liberate meaning, even if it suggests contradiction. 'I have a double self', Stendhal once said, 'a good way of not making mistakes'. Almost from the start,

Hirst has made the distinction between 'delicious, desirable images of completely undesirable and unacceptable things' (and has inevitably drawn on the precedents of Bosch, Goya, Géricault and Bacon, as well as gruesome medical photographs). Most of his successful works have achieved an equilibrium or reconciliation between the two.

Hirst's formal vocabulary is familiar and simple. By this I mean he uses known methods of presentation ranging from past art to museum and shop display. Classic American minimalism – boxes, grids, stacks, repetition – influenced him almost from the

A Thousand Years
(detail)
1990

beginning but with the difference that his massive glass cases are not self-referential but work as containers to hold the event within. **A Thousand Years** (p. 020) takes place in two adjoining steel and glass boxes, allowing the viewer maximum exposure to the futile natural cycle inside, which is dependent on the hour holes cut into the interior glass panel. The glass frontages of the medicine cabinets and of **Isolated**

Elements... (p. 027) obviously fulfil their original function in pharmacies and museum or trophy display. They are unthreatening. But the glass of the formaldehyde-filled tank in **The Physical Impossibility...** (pp. 010–013) has a much more fearsome charge to it, the tiger-shark inside reminding us of glass's protective role as well as its fragility and potential danger (akin to the window of the diner through which we see but cannot hear Robert de Niro in **Goodfellas** planning unspeakable acts). At the same time, the huge tank has its origins in the ubiquitous domestic aquarium, a simple formal precedent that works into the nervous system of the viewer. Most disconcerting is the lamb in **Away From the Flock** (pp. 017–018), one of Hirst's simplest inventions and most complexly allusive images. The animal's very woolliness seems at odds with the formaldehyde solution, its open-air gambols forever halted by the tightly containing tank, allowing us to contemplate it in all its Pre-Raphaelite detail. We are made acutely aware of its poignant vitality and obvious religious and sentimental connotations by the condition of its being buried alive in fluid.

Through the 1990s, images of diseased, dying and slaughtered cattle have assailed us in the media, most recently in the flaming pyres of animals during the foot-and-mouth crisis. 'Medical' experimentation on animals and animal cloning, recycled feed, BSE and the issue of cruel rural 'sports' have forced many people into rethinking their views on animal welfare, meat consumption and the relation of countryside tradition to contemporary sensibilities. Even domestic pets became the subject of anxious enquiry. As chief exporter of infected animal feed in the 1980s and 1990s, Britain is seen, almost certainly, as the source of BSE, a by now global affliction. With all this in mind, Hirst's works, mostly from the mid-1990s, of halved and dissected cows and pigs, take on an inescapable resonance. They are by no means programmatic; Hirst is no eco-warrior, no courier of catastrophe pointing a finger from his rural retreat in Devon. But, plugged into collective fears and frustrations, he articulates them as an artist in prescient images.

There are some themes that Hirst leaves to others – sexuality is one, socio-political commentary is another. Both need some figural input that Hirst usually avoids. Nevertheless, if rarely portrayed

Amphotericin B
(detail)
1993

directly, the human figure is an implied presence through much of his work, whether as spectator, voyeur or as an essential, if absent, ingredient as in **The Acquired Inability to Escape** (1991) or the later **Contemplating a Self-Portrait (as a Pharmacist)** (pp. 061–063). The naked or semi-naked body has been a continuous image in recent British art, evocative of trauma, sexuality, death and transcendence. It has rarely been used for its erotic or sensual properties: these tend to be subsumed under scatological or **Carry On** humour peculiar to Britain. But as a vehicle for vulnerability and victimisation it has a recent history that is copiously theatrical while at the same time seeming to be objective, at one remove from life.

Hirst's **Hymn** (1999) was his first major representation of the human body, accurately based, as noted earlier, on a commercially available Humbrol toy of a semi-skinned male, designed as an anatomical teaching aid. Hirst's greatly increased painted bronze bears as much relation to the original as does a Nile-side Pyramid to a similarly shaped piece of Lego. **Hymn** is best approached from the unskinned right side, a heroic athlete from the Foro Italico. As you come round to the front, the

skin has been removed from half the head and all the trunk (the sculpture stops at mid-calf, rising from its shiny black plinth), revealing musculature and organs upholstering the skeleton beneath in High Street furnishing style. This is no **Ecce Homo** or **Angel of the North**: Hirst has never satisfied those seekers after spiritual uplift for whom so much contemporary art is thus a closed book. Here is automaton, phallus, fetish, specimen and god. In spite of the figure's homage to the sculpture of the ancient world, its robotic eye and gift-shop colour, Hirst manages to invest it grandeur while simultaneously writing the obituary of scientific certitude.

The archetypal forms and simplicity of approach of much of Hirst's three-dimensional work are also found in his painting. Hirst

Isolated Elements
Swimming in the
Same Direction for
the Purpose of
Understanding
(detail)
1991

started as a painter and collagist and has always been a compulsive draftsman. While his sculpture has garnered the headlines, his continuing activity as a painter has been less scrutinised. His first notable paintings, in which butterflies adhered to monochome

paint surfaces, were part of his spectacular installation **In and Out of Love** (1991). Since then two extensive series – 'spots' and 'spins', executed by assistants – have become his trademark. As might be expected from Hirst, they investigate two basic forms of modernist abstraction – idealised geometry and gestural freedom, both taken at their most extreme, interrogatory point. The multi-coloured Pharmaceutical Paintings, produced over a period of several years, are based on an infinitely extendable grid over a white ground of single-colour circles that vary in size from painting to painting but not within a single work. Their effect seems to rebuke the 'rationality' of their making, for they are astonishingly different in impact, ranging from toy-town blandness to mesmerising complexity, from static austerity to an engrossing field of shifting movement. Snooker balls, traffic lights, logos, cellular formations, early Gerhard Richter, photographic pixillation, even the coloured 'tester' spots that appear along the edge of a sheet of newsprint – all these have fed into or emanate from paintings that are salutary in their contentlessness. The spin paintings, from 1994 onwards, are again the result of an extremely basic idea of dropping pigment onto a circular support

laid flat on a motorised table. Their chancy spontaneity is in direct contrast to the paint-by-numbers regularity of the Pharmaceutical series (both aspects reflected in the works' individual titles). But they have a garrulous, infantile presence that strikes a note of relief after so much so-called 'good' painting by grown-ups.

Hirst is now 36, a critical age for artists moving forwards from rampant early invention. His formative years as an artist were spent in the public eye and every new work he showed was met with frantic attention. He has already taken his place in the history books and surveys as the leading spirit in British art in the last decade. If he has had little direct influence and no imitators (save in the ever-imitative media), his work has served instead as a yardstick by which to measure the ambitions of others in a generation of high-profile artists. This position has been attained through an exemplary belief in what he has been doing – the reinterpretation of familiar feelings and perceptions in a striking visual language. Though much of his work is shot through with the dystopian character of the times, it is also celebratory in its power to amaze.

Damien Hirst*

Press Headlines 1989–2001

75mg

Dosage: as directed by your practitioner

The gold rush/The fast dockland track to simplicity/It's a maggot farm: the b-boys and fly girls of British art/Daily Star takes the chips to the world's most expensive fish/Our 'sculpture' is shoal lot better/Hatching a scheme/Charlie is their

darling/Schools of small fish in the Saatchi pond/Celebrities flock to gaze at a cow's head and a dead shark/Tanks for the memories/ Begraven achter glas/ Is something rotten in the world of art?/Great white hopes/Disturbing

092

symbols of death/
Baa-rmy! £25,000 for
one dead sheep: carcass
is star of wacky show/
The A to Z of art: D is
for Damien/Black sheep,
white sheep/Sheep
exhibit attack 'an artistic
statement'/Life, death
and the meaning of a

two-tone sheep dip/
Decadent geometry/
Knight of the living
dead/Art failure/D&AD
ditches 'Hirst' poster/
Problems with dead
cows/Another Turner for
the worst/Damien Hirst
and the dark side/Gallery
turns up nose at Hirst's

094

rotting cows/Tate cleared as art work leaks poison/Sins of emission/ Rotten art causes a stink/ Not one drop of British reserve/Is this artist safe?/Sweet sorrow for Damien and Jay?/Damien Hirst in a spin over canvas junked in skip/

Wild man at art/He loves you/Customs give artist plenty to beef about/Spin children join art's inner circle/Art tartare/British beef goes to France/Plagiarism pickled/Hirst world/Dead shark, a concrete room and artist's blood… welcome to the

Royal Academy/The big, fat, stuffy Royal Academy, by Hirst/We laughed at the pickled sharks and cows' heads, but now Damien Hirst and his brat pack rule Britain's art world. And the joke is on us/Sorry Damien, however hard you try,

you've become passé/
Brits pack them in
stateside/Avoiding the
sharks/You can puff all
you like Damien, but
the wind's gone out of
Britart/Hirst and White
get themselves in a
pickle/Organs of cows?
Young art sells/Hirst

098

painting going to Mars/ 'A lot of people came and were very disappointed with the Damien Hirst art collection'/Damien Hirst almost behaves/After shock/Sharks and dinosaurs/Road to infamy: factors that conspired to create an icon/Designer

spills – Notting Hill's unique Pharmacy remains a one-off/Hirst breaks mould with £1m bronze/Hymn sees Hirst join £1m club/Hirst's £1m sculpture is copy of £14.99 toy/Hirst or hoax/Hirst owes me a design fee says sculptor of copied toy/Hirst stole

our idea says firm/What
Damien did next/The
knives are out/Hirst
produces a human form
at last/Hirst work turns
art inside out/Size is a big
thing for artists/Hirst steals
the show/Hirst not the
first — but his torso is
more so/Is it art, a parody

or blatant imitation?/
Nothing acts faster than
anodyne/Million pound
man/Melting pot where
art meets cast/Knaves of
arts/A freak, an angel but
no delight/Hirst pays up
for Hymn that wasn't
his/Charity gift averts
legal action over Hirst

102

sculpture/Toy copy row ends in payout/A master work – be it never Humbrol/Damien Hirst pays up for his anatomy lesson/They must be dotty/Being Damien Hirst/In Damien Hirst's big, shiny universe, glass & steel meet

pills & pain/An artist? I'm a brand name, says Hirst/New York is aflutter as Hirst's butterflies make a record $750,000/ Big fish in a big pond/ Damien Hirst: artist or brand?/Damien Hirst's lost weekend/Faecal attraction/

ACKNOWLEDGEMENTS

We would like to thank the following
photographers for the use of their material:

Peter Hauck, Basel; Robert McKeever;
Anthony Oliver; Susan Ormerod;
Mike Parsons; Stephen White;
Gareth Winters; J. Ziehe, Berlin.

PRESS HEADLINES

The gold rush **City Limits** 23–30 November 1989/The fast dockland track to simplicity **The Guardian** 13 September 1989/It's a maggot farm: the b-boys and fly girls of British art **Artscribe** November 1990/Daily Star takes the chips to the world's most expensive fish: Our 'sculpture' is shoal lot better **Daily Star** 27 April 1991/Hatching a scheme **The Independent** 16 July 1991/Charlie is their darling **Sunday Times Magazine** 8 March 1992/Schools of fish in the Saatchi pond **The Guardian** 13 March 1992/Celebrities flock to gaze at a cow's head and a dead shark **Daily Mail** 6 March 1992/Tanks for the memories **The Times** 3 April 1992/Begraven achter glas **NRC Handesblad** 27 March 1992/Is something rotten in the world of art? **Daily Mail** 6 March 1992/Great white hopes **The Independent**/10 March 1992/Disturbing symbols of death **The Daily Telegraph** 11 March 1992/Baa-rmy! £25,000 for one dead sheep: carcass is star of wacky show **The Sun** 5 May 1994/The A to Z of art: D is for Damien **The Modern Review** June–July 1994/Black sheep, white sheep **The Guardian** 14 August 1994/Sheep exhibit attack an 'an artistic statement' **The Daily Telegraph** 17 August 1994/Life, death and the meaning of a two-tone sheep dip **The Guardian** 19 August 1994/Decadent geometry **Parkett** 1994/Knight of the living dead **The Times Magazine** May 20 1995/Art failure **Evening Standard** June 20 1995/D&AD ditches 'Hirst' poster **Campaign** 14 July 1995/Problems with dead cows **New York Magazine** 4 August 1995/Another Turner

for the worst **Evening Standard** 17 November 1994/Damien Hirst and the dark side **The New York Times** 4 August 1995/Gallery turns up nose at Hirst's rotting cows **The Sunday Times** August 6 1995/Tate cleared as art work leaks poison **The Times** August 7 1995/Sins of emission **Evening Standard** August 8 1995/Rotten art causes a stink **The Art Newspaper** September 1995/Not one drop of British reserve **The New York Times** 22 October 1995/Is this artist safe? **The Independent** 26 March 1996/Sweet sorrow for Damien and Jay? **The Sunday Telegraph** 14 April 1996/Damien Hirst in a spin over canvas junked in skip **The Guardian** 22 April 1996/Wild Man at Art **W Magazine** May 1996/He loves you **The Village Voice** 21 May 1996/Customs give artist plenty to beef about **Daily Express** 1 May 1996/Spin children join art's inner circle **The Sunday Times** 5 May 1996/Art tartare **New York Magazine** 13 May 1996/British beef goes to France **The Art Newspaper** May 1996/Plagiarism pickled **The Art Newspaper** October 1996/Hirst world **The Guardian** 31 August 1996/Dead shark, a concrete room and artist's blood… welcome to the Royal Academy **The Guardian** 28 February 1997/The big, fat, stuffy Royal Academy, by Hirst **Evening Standard** 19 September 1997/We laughed at the pickled sharks and cows' heads, but now Damien Hirst and his brat pack rule Britain's art world. And the joke is on us **The Mail on Sunday** 26 July 1998/Sorry Damien, however hard you try, you've become passé **The Independent** 30 May 1998/

Brits pack them in Stateside **Evening Standard** 27 May 1998/Avoiding the sharks **The Guardian** 14 February 1999/You can puff all you like Damien, but the wind's gone out of Britart **The Guardian** 16 March 1999/Hirst and White get themselves in a pickle **The Guardian** 2 May 1999/Organs of cows? young art sells **The New York Times** 11 December 1998/Hirst painting going to Mars **The Guardian** 2 June 1999/'A lot of people came and were very disappointed with the Damien Hirst art collection' **The Guardian** 17 June 1999/Damien Hirst almost behaves **The New Yorker** September 20 1999/Sharks and dinosaurs **The Guardian** 1 October 1999/Road to infamy: factors that conspired to create an icon **The Guardian** 26 October 1999/Designer spills – Notting Hill's unique Pharmacy remains a one-off **The Guardian** 29 October 1999/Hirst breaks mould with £1m bronze **The Sunday Times** March 26 2000/Hymn sees Hirst join £1m club **Metro** March 27th 2000/Hirst's £1m sculpture is copy of £14.99 toy **The Sunday Times** 2 April 2000/Hirst or hoax **The Times** April 3 2000/Hirst owes me a design fee says sculptor of copied toy **The Times** April 4 2000/Hirst stole our idea says firm **Evening Post** April 4 2000/What Damien did next **The Guardian** April 10 2000/The knives are out **The Guardian** April 10 2000/Hirst produces a human form at last **Yorkshire Post** April 19 2000/Hirst work turns art inside out **The Post** April 19 2000/Size is a big thing for artists **News North West** April 19 2000/Hirst steals the

show **Star** April 20 2000/Hirst not the first – but his torso is more so **The Journal** 20 April 2000/Is it art, a parody or blatant imitation? **The Times** April 25 2000/Nothing acts faster than anodyne **The Independent** 26 April 2000/Million pound man **The Daily Telegraph** April 26 2000/Melting pot where art meets cast **The Times** 29 April 2000/Knaves of arts **The Spectator** 29 April 2000/A freak, an angel but no delight **Evening Standard** 12 May 2000/Hirst pays up for Hymn that wasn't his **The Guardian** 19 May 2000/Charity gift averts legal action over Hirst sculpture **The Daily Telegraph** 19 May 2000/Toy copy row ends in payout **Gloucestershire Echo** 19 May 2000/ A master work… be it never Humbrol **Yorkshire Post** 20 May 2000/Damien Hirst pays up for his anatomy lesson **The Guardian Weekly** 25 May 2000/ They must be dotty **Classic Car Weekly** 5 July 2000/Being Damien Hirst **Hot Air Magazine** July–September 2000/In Damien Hirst's big, shiny universe, glass & steel meet pills & pain **New York Times** September 29, 2000/An artist? I'm a brand name, says Hirst **The Independent** 1 October 2000/New York is aflutter as Hirst's butterflies make a record $750,000 **The Independent** 16 November 2000/ Big fish in a big pond **Evening Standard** 28 November 2000/Damien Hirst: artist or brand? **Art Review** November 2000/Damien Hirst's lost weekend **Vanity Fair** December 2000/Faecal attraction **Art Review** February 2001